DREADFUL CREATURES

by Isidro Sánchez
Models by Roser Piñol
Photographs by Juan Carlos Martínez

Gareth Stevens Publishing
MILWAUKEE

For a free color catalog describing Gareth Stevens' list of high-quality books,
call 1-800-542-2595 (USA) or 1-800-461-9120 (Canada).
Gareth Stevens' Fax: 414-225-0377.

Library of Congress Cataloging-in-Publication Data

Sánchez, Isidro.
 [Brujas, gigantes, ogros y fantasmas. English]
 Dreadful creatures / text by Isidro Sánchez ; models by Roser Piñol ;
photography by Juan Carlos Martínez.
 p. cm. — (Draw, model, and paint)
 Includes index.
 Summary: Provides instructions for creating such creatures as gnomes, ogres,
giants, witches, skeletons, and even a haunted castle, using a variety of materials.
 ISBN 0-8368-1522-X (lib. bdg.)
 1. Handicraft—Juvenile literature. 2. Monsters in art—Juvenile literature.
[1. Modeling. 2. Handicraft. 3. Monsters in art.] I. Piñol, Roser.
II. Martínez, Juan Carlos, 1944- ill. III. Title. IV. Series.
TT160.S175 1996
745.592—dc20 95-43909

This North American edition first published in 1996 by
Gareth Stevens Publishing
1555 North RiverCenter Drive, Suite 201
Milwaukee, Wisconsin 53212, USA

Original edition © 1995 Ediciones Este, S.A., Barcelona, Spain, under the title
Brujas, Gigantes, Ogros Y Fantasmas. Text by Isidro Sánchez. Models by
Roser Piñol. Photographs by Juan Carlos Martínez. All additional material
supplied for this edition © 1996 by Gareth Stevens, Inc.

Series editor: Barbara J. Behm
Editorial assistants: Jamie Daniel, Diane Laska, Rita Reitci

Printed in the United States of America

1 2 3 4 5 6 7 8 9 99 98 97 96

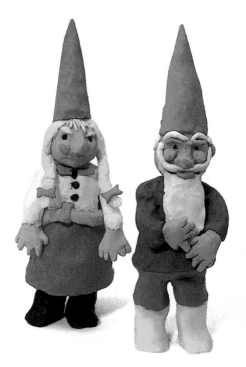

CONTENTS

Tiny gnomes

Gnomes are friendly little imaginary people who supposedly live in forests and gardens. Most gnomes are said to be only 3-4 inches (7-10 centimeters) tall. A gnome would easily fit in the palm of your hand!

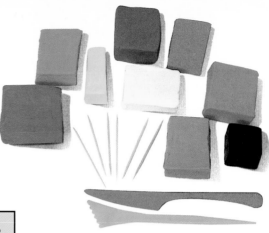

You will need:
- modeling clay
- palette knives
- toothpicks

2. For the male gnome, start by shaping a ball of clay for the pants and another for the shirt.

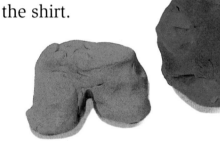

1. For the female gnome, start by shaping a ball of clay for the skirt and another ball for the blouse.

3. To make the heads, roll out two balls of clay of any color. Shape the features of the faces on the balls with your fingers.

4. Roll out two thick pieces of clay, as shown, for the gnomes' hats. Mold them so each hat has a pointed top.

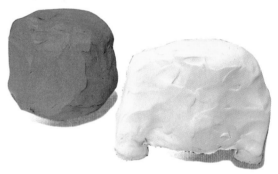

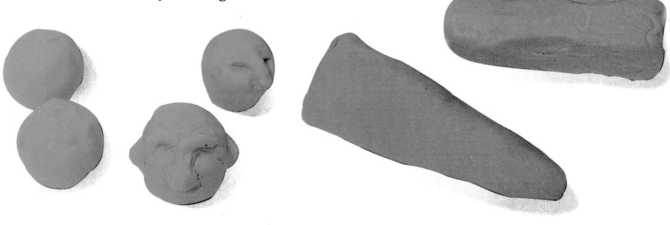

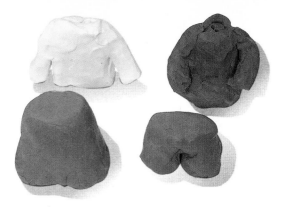

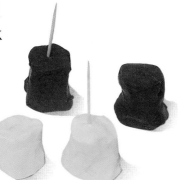

6. Form the hands and boots from short, thick pieces of clay. Insert toothpicks in the tops of them.

5. Insert a toothpick in the skirt, to which you will later attach the blouse. Insert a toothpick in the pair of pants, to which you will later attach the jacket.

7. Join together the pieces you have so far. Place a toothpick into the head of each gnome. Later, you will place hats on these toothpicks.

11. The gnomes have turned around so you can see how they look from the back.

8. Make the female's hair by rolling out a long piece of clay. Shape the top, as shown. Then, shape the ends on both sides into braids. Make eyebrows from two tiny pieces of clay.

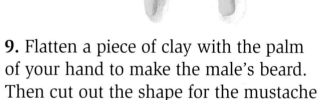

9. Flatten a piece of clay with the palm of your hand to make the male's beard. Then cut out the shape for the mustache with a palette knife. Use the extra clay for the eyebrows and hair.

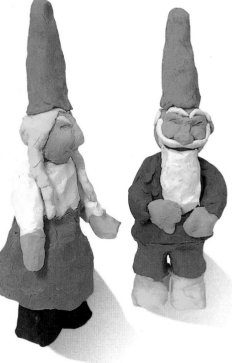

10. Attach the hair and hats to the gnomes' heads by placing them over the toothpicks. Press on the eyebrows.

12. Shape accessories like these for the female gnome – a belt, hair ribbons, and buttons – plus eyes, lips, and rosy cheeks. Shape final touches for the male gnome, too. Make them all from small balls or coils of clay. Press them on the bodies, and shape them a little more with your fingers.

13. To make the gnomes complete, smooth the clay with a palette knife.

An awful ogre

An ogre is one of the most ferocious imaginary creatures ever. The ogre shown here is a bit more on the friendly side, however. He'll make a great addition to your toy collection!

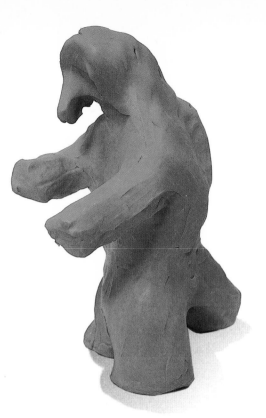

2. Press the pieces of clay together. Remove any unwanted clay, and continue shaping the ogre.

You will need:
• modeling clay
• palette knives

1. Shape the main part of the ogre's body from a large piece of clay. Shape its head and tail from smaller pieces of clay.

3. Smooth the clay by running a palette knife over the surfaces.

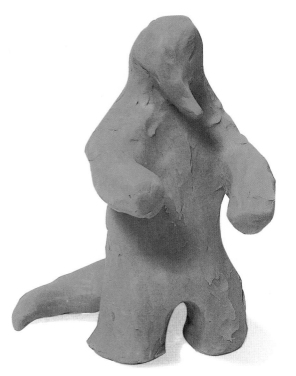

5. Make the ears more pointed and the nose a bit longer. Smooth over the entire body with a palette knife.

4. Shape the ears, nose, and fingers. Make the pants from a piece of blue clay that you have flattened with your hand. When it is flat enough, press it onto the ogre's body.

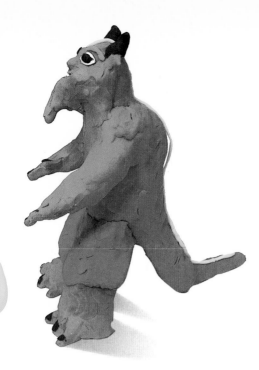

7. Press these objects onto the ogre's body. Take your time to attach the teeth very carefully, one by one.

9. Roll out a long, thin rope of clay like the one shown. Press it onto the ogre, starting at the top of the head and running it down the back to the tip of the tail.

8. Attach the claws, one at a time. Press gently, but firmly. Take your time.

6. Make the horns, eyebrows, eyes, teeth, cheeks, nostrils, and claws to add to the figure.

11. For the final touch, smooth over the ogre once again, and add extras like a pants button and anything else you would like!

10. Make suspenders from two long ropes and one short rope of clay. Attach the suspenders as shown.

A menacing mountain giant

The mountain giant is a very special giant. Its body is brown like the soil and green like the trees. There are also touches of snowy mountain white all over its body.

3. This is how the giant looks from the back.

2. After shaping the giant's head, shoulders, and hips, use a palette knife to remove any unwanted clay.

You will need:
- modeling clay (brown)
- "slip," which is made by mixing small chunks of clay with water until a paste forms
- palette knives
- a paintbrush
- tempera paints
- containers of water

1. Start by shaping a big chunk of clay with your hands. Make the basic shape of the giant.

4. Add pieces of clay where necessary. Attach these pieces to the body with slip.

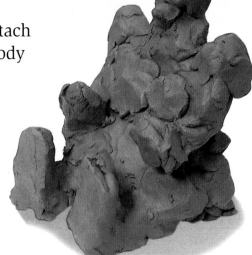

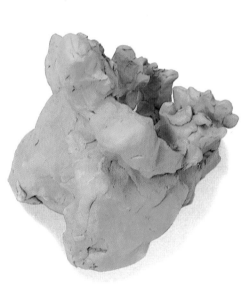

5. Here is another view of the mountain giant from the back.

6. Your mountain giant doesn't have to look just like the one here. Use your imagination to decide how you want him to look.

10. Add green patches to the giant – light green and dark green.

9. Brush on some paint in various other shades of gray. Mix the shades by adding greater or lesser amounts of black paint to white paint.

7. Wait a day for the clay to dry. Then mix a little black paint into white paint to get gray. Starting with the head, paint the entire giant gray.

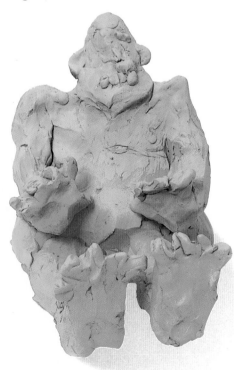

8. After painting one coat of gray, check to see if there are any patches you missed and paint them. Wait for the paint to dry, and wash your brush between each color you use.

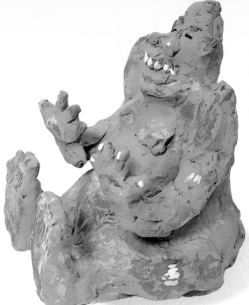

11. Paint the teeth, nostrils, and claws white. Add snowy patches of white to other areas of the giant.

12. Add final touches of brown and light blue.

A good witch

The good witch plays an important role in many fairy tales. A good witch can use her magic charm to undo bad spells cast by wicked witches. The good witch on these pages is the kind of witch you would want to have looking out for you!

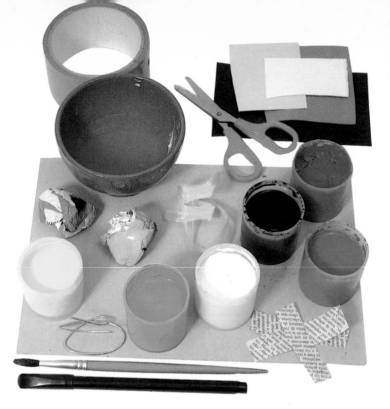

You will need:
- white posterboard
- a black felt-tip pen
- construction paper
- containers of water
- tempera paints
- art paste (from an art supply store)
- wire
- tape
- scissors
- yellow ribbon
- a paintbrush
- newspaper
- glue

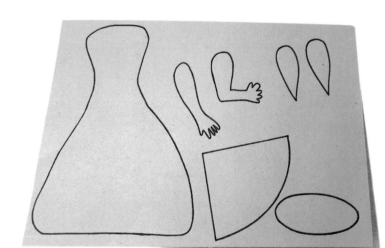

1. With a black felt-tip pen, draw the witch's body, shoes, and hat on posterboard as shown.

2. With scissors, cut out the pieces you have drawn.

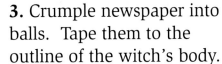

3. Crumple newspaper into balls. Tape them to the outline of the witch's body.

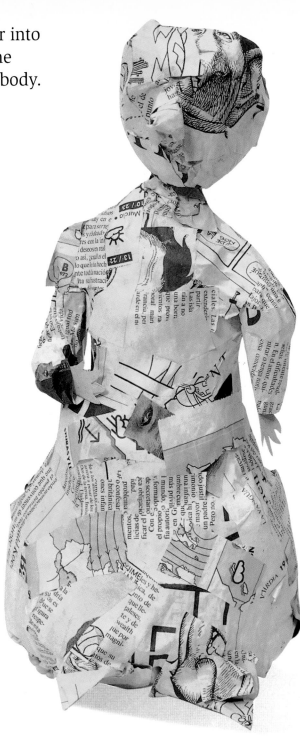

4. Attach the arms and shoes to the witch's body with tape.

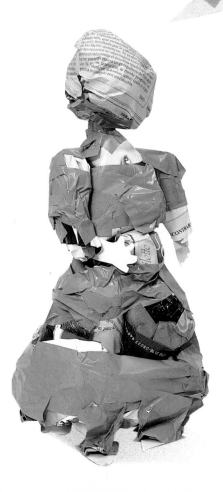

5. Attach paper balls to the arms, shoes, and back of the posterboard, as well. Wrap the entire figure around and around with tape, as shown. Make the head by crumpling one big ball of paper. Attach it securely to the body with tape.

6. Prepare the art paste. Cut out several strips of newspaper. Dip the strips in the paste, and place them on the figure. Continue adding strips until the figure is completely covered, as shown. Then, let the model dry.

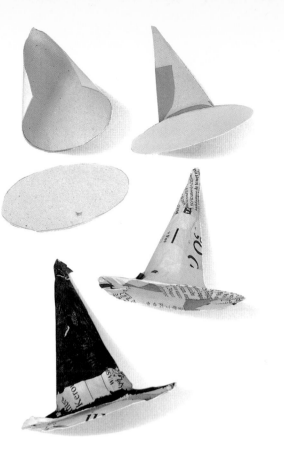

7. Next, paint the dress black, leaving the neck and a space below it unpainted, as shown. Paint the toes of the shoes black, too. Wash your paintbrush between colors. Paint the head and hands any color you like.

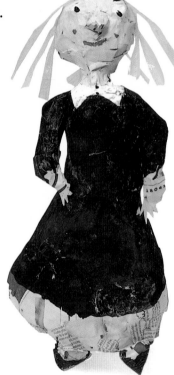

10. Roll up the piece of posterboard for the hat into a cone, and tape the edges together. Add the brim, as shown. Paint the hat black, with a blue band.

9. Glue on strips of yellow ribbon for the hair.

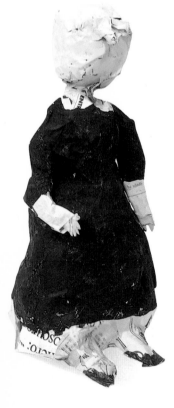

8. Once the head is dry, paint the features of the face. Then, paint areas of the dress, shoes, and feet.

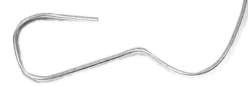

11. Have an adult help you make the witch's glasses by bending a piece of wire, as shown.

12. Cut and fold some colored construction paper to make the pages and cover of the good witch's book of magic potions. Draw a design on the cover of the book. Write a potion on the inside pages. Use another piece of construction paper to make the magic charm she holds in her other hand.

13. Glue the hat to the head. Glue the book and magic charm to her hands. Now put your good witch in a safe place where she will bring you good luck!

A scary skeleton

You will need:
- a black felt-tip pen
- a paintbrush
- white posterboard
- wire and wire cutter
- a container of water
- Plaster of Paris roll
- tape
- scissors
- magazine paper
- glue
- modeling clay
- tempera paints

3. Have an adult help you cut and bend a piece of wire for the head and neck, as shown. Don't forget the little hook at the top of the head. Cut more pieces of wire for the shoulders, arms, spine, hips, and legs. Twist the wires together into a frame, as shown.

When you finish this skeleton, you can hang it in your room to scare all your friends and even yourself!

1. On a piece of posterboard, draw these parts of a skeleton.

2. Cut the pieces out with scissors.

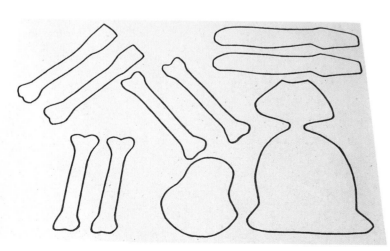

6. Remember, do not cover the joints.

7. Continue to add plaster strips until you are satisfied with the look of the skeleton.

5. Wrap the entire frame, except for the joints, with narrow strips of Plaster of Paris dipped in water.

4. Crumple magazine paper into small balls. Attach them to the middle area of the frame with tape. Next, tape all the posterboard pieces you cut out onto the frame, as shown.

10. Wash your brush between colors. After the yellow paint is dry, paint the spine and ribs with light brown paint.

9. Examine the paint after it is dry. If it looks too light or you've missed any spots, add a second coat.

8. After the Plaster of Paris strips dry, paint the entire skeleton light yellow. Start with the upper areas and move downward.

11. Then, outline the bones with dark brown and white paint, as shown.

12. Add eyebrows, fingers, toes, cheekbones, and nostrils with brown paint. Paint the mouth white. Create teeth by drawing them in with a black felt-tip pen. Roll out two small balls of blue modeling clay for the eyes. Then, your skeleton is done! Hang it from the ceiling or another object with a piece of wire.

Flying witches

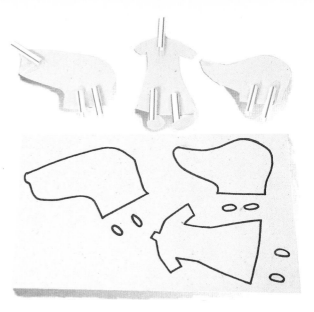

Witches love to fly high in the sky on their broomsticks so they can kiss the moon good night.

4. Draw and cut out the bodies and shoes from posterboard. Cut drinking straws into small sections for the legs and necks, and tape them in place.

3. Use Styrofoam balls, painted whatever color you like, for the heads. Make noses from posterboard, and tape them to the heads. Paint on eyes and mouths. Make a hole in the bottoms, as shown, for joining the heads to the necks.

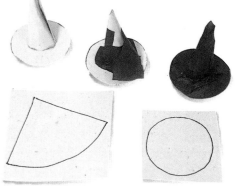

2. Make hats by cutting these pieces from posterboard and taping them together. Cover them with black tissue paper.

1. Cover three chopsticks with tissue paper. Glue ribbon to one end of each stick for broomsticks for three witches.

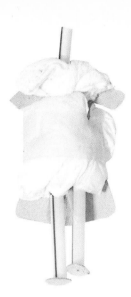

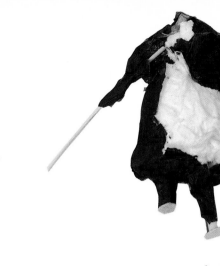

5. To make the bodies, tape cotton balls to the posterboard, as shown. Tape the shoes on the bottoms of the legs.

6. Make arms from toothpicks, as shown, and tape them in place. Cover each of the bodies, including the arms, with black tissue paper.

7. Attach the heads to the bodies by placing them over the straws.

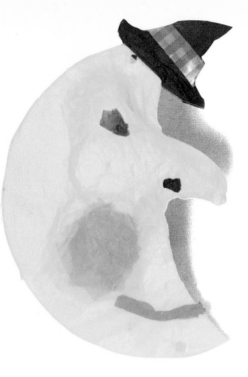

9. Cut a paper plate into the moon shape you see here. Make the "cheeks" and "nose" of the moon bulge out by taping cotton to these areas.

11. Paint a mouth, cheeks, nostril, and eye on your moon. Make a hat from some black tissue paper and fabric, and glue it on.

10. Cover the moon with yellow tissue paper. Use small pieces to cover the cheeks and nose.

8. Glue straw on the heads for hair. Cut capes out of tissue paper, and decorate them with buttons. Cut out the pieces of the aprons from fabric scraps, as shown.

12. Decorate the hats with ribbon and foil. Add touches of paint or tissue paper to complete the hands, arms, legs, feet, and capes. Glue each witch to her broomstick, as shown.

13. When the glue has dried, make a mobile. Tape two sticks together in an *X* shape for the frame. Tie thread to each of the three broomsticks, and hang them from the frame. Tie a thread to the moon and hang it, too. Then, hang your mobile in a window or doorway, and watch the witches fly!

A haunted castle

This haunted castle will bring you hours of fun. And it will make the perfect home for all your dreadful creatures!

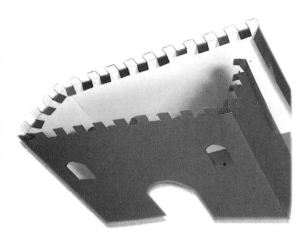

2. Cut out the castle, including the door and windows, as shown. Then fold the posterboard on the lines.

3. Draw these pieces (the castle doors, windows, etc.) on black posterboard in sizes that will fit the castle you have just built. Decorate and cut out the pieces.

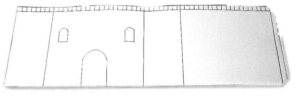

1. Draw the walls of the castle on gray posterboard, as shown.

You will need:
- Styrofoam balls
- needle and thread
- container of water
- a black felt-tip pen
- posterboard
- tape
- fabric
- scissors
- tempera paints
- glue
- a paintbrush

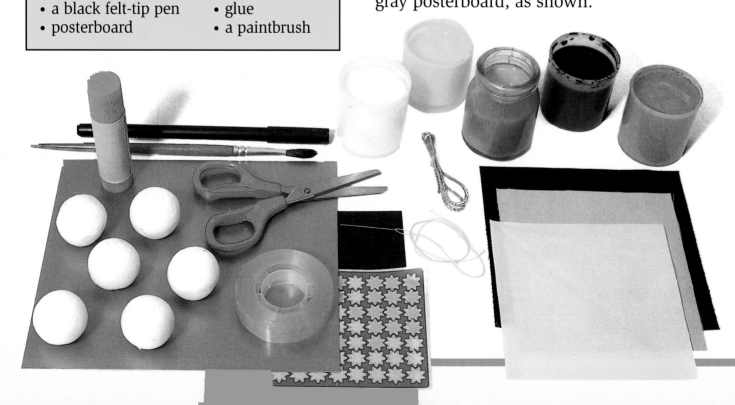

4. On gray posterboard, draw and cut out two towers that look like this. Remember to cut out the tower windows.

5. Roll up the towers, and tape them together, as shown.

6. Glue on the doors and windows from inside the castle. Then, glue the flat roof in place. Tape the towers to the roof. Roll up and add the tower roofs.

9. Lift up the squares, and watch them turn into ghosts!

8. For each cloth, join two of the corners together, and then fold the other two inward, as shown.

7. Cut a piece of fabric into a square for each ghost you want to make. "Sew" a needle and thread through a Styrofoam ball and through the center of the fabric. Remember to make a knot at the end of the thread.

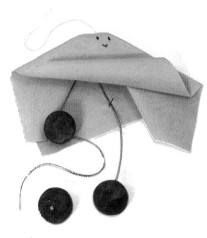

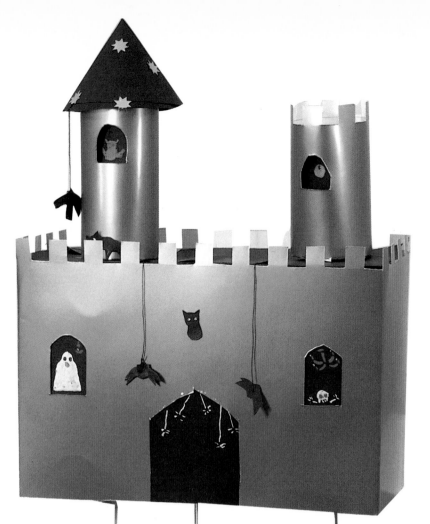

10. Paint some Styrofoam balls black. When they are dry, use your needle and thread to sew them to the ghosts, as shown above.

11. Paint faces on your ghosts. Then tape them to the castle by the thread. To complete the haunting of the castle, make bats and cats from black fabric, and put them in various scary places!

Glossary

accessories: items that are added to an object to make the object more elaborate.

chopsticks: thin pieces of wood that serve as eating utensils. They originated in many Asian countries.

haunted: visited or inhabited by ghosts or other dreadful creatures.

imaginary: something that isn't real but exists only in the mind.

magic: having supernatural powers or qualities.

mobile: a work of art that hangs in the air and moves in the wind.

palette knife: a flat, knife-like tool used in sculpting and modeling. It is usually made of plastic or wood.

potion: a mixture of ingredients that some people think has magical powers.

skeleton: the bone structure that supports the body of a human or animal.

slip: a substance used to bond pieces of clay together. It is made by mixing small chunks of clay with water until a paste forms.

tempera paints: paints that are mixed with water.

Books and Videos for Further Study

Ghosts, Monsters and Legends. Bradley (Mad Hatter Publishing)

Horrorigami: Spooky Paperfolding Just for Fun. Saunders (Sterling)

Monster Manual: A Complete Guide to Your Favorite Creatures. Ballinger (Lerner Publications)

Monster Myths: The Truth about Water Monsters. Rabin (Watts)

Monsters, Dinosaurs and Beasts. Kallen (Abdo and Daughters)

Monsters, Strange Dreams, and UFOs. Emert (Tor Books)

Worldwide Crafts (series). Deshpande and MacLeod-Brudenell (Gareth Stevens)

The Lion, the Witch and the Wardrobe. (PBS Video)

Mummies Made in Egypt. (Reading Rainbow Video)

My Pet Monster. (Hi-Top Video)

The Reluctant Dragon. (Disney Video)

Index